DRAGONART™ COLOR WORKBOOK

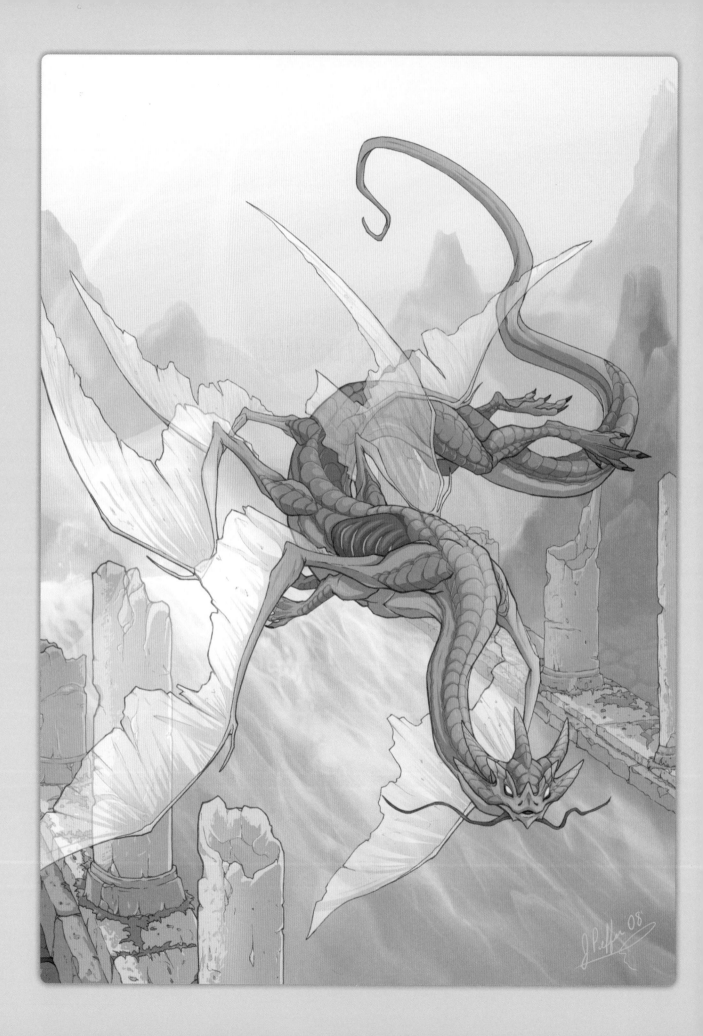

DRAGONART™
COLOR WORKBOOK
Explore New Coloring Techniques

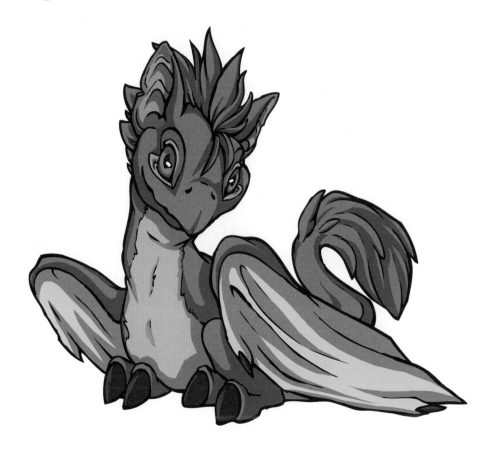

J "NEONDRAGON" PEFFER

IMPACT
CINCINNATI, OHIO
www.impact-books.com

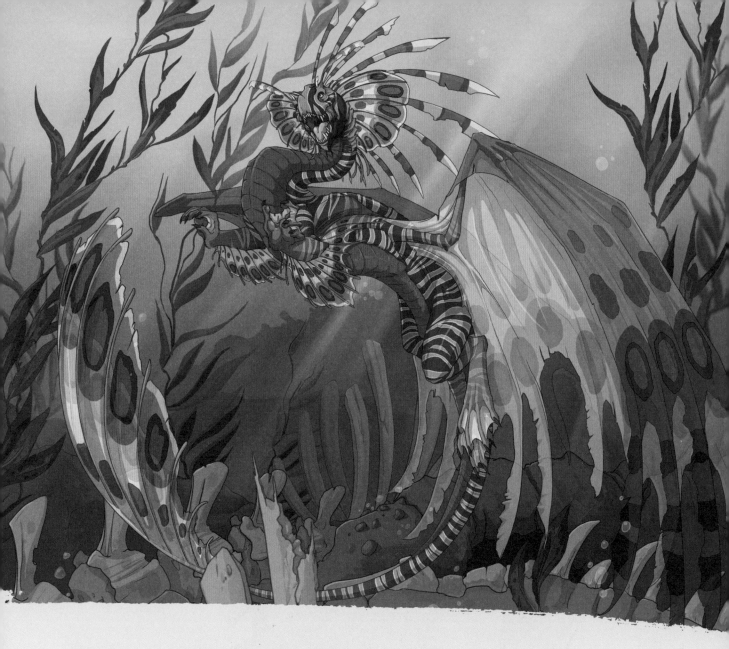

Contents

Color and Pattern Considerations

Choosing the coloration for your dragon is as important as having a unique, anatomically believable design. The right colors can make your dragon shine, while the wrong ones can make it cringe-worthy. When talking about color, there are a few terms you might run into:

- *Hue* refers to where on the color wheel or rainbow the color falls.

- *Value* refers to how light or dark the color is.

- *Chroma* refers to how intense the color is.

Do

Don't

Pure White vs. White Isn't White

So you thought you'd start simple and just make your dragon white? Remember that white isn't really white. You can use a variety of light grays and pastel tints to add more interest.

Do

Don't

Saturated Colors vs. Neutral Colors

When choosing colors for your dragon, remember that they don't always have to be the brightest, most chromatic version of that hue available. Sometimes a less chromatic brick red can be more effective than an eye-popping one.

5

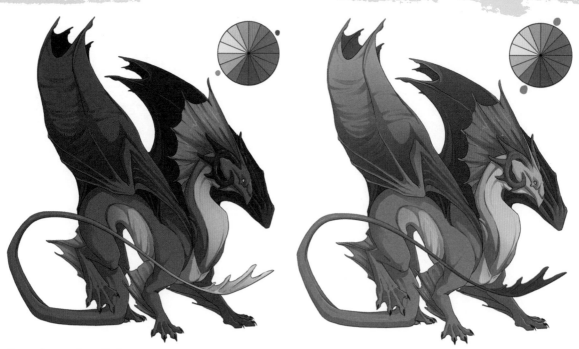

Complementary Colors

When choosing a color combination, a set of complementary colors can often produce a lovely result. The complement will always be across the color wheel from its opposite.

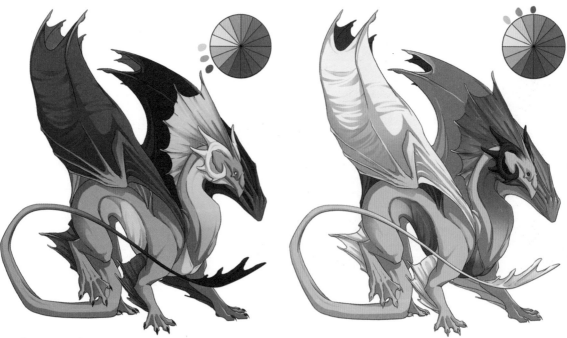

Analogous Colors

Another color strategy is to work in a color family, and not deviate too much in hue. Using a variety of yellow-greens, greens and blue-greens creates more interest than painting the entire dragon the same color all over.

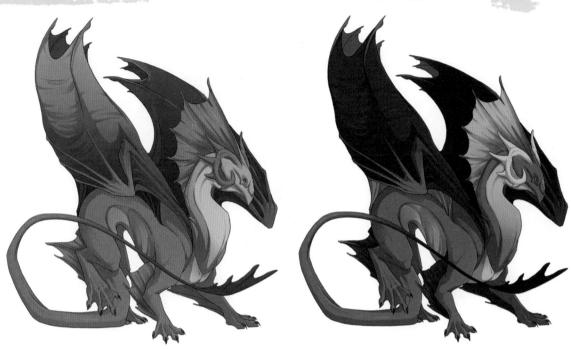

Chroma Contrast

When a bright, chromatic color is placed next to neutral colors, it will seem to "pop" and almost glow. This same red placed next to equally chromatic colors does not have this effect.

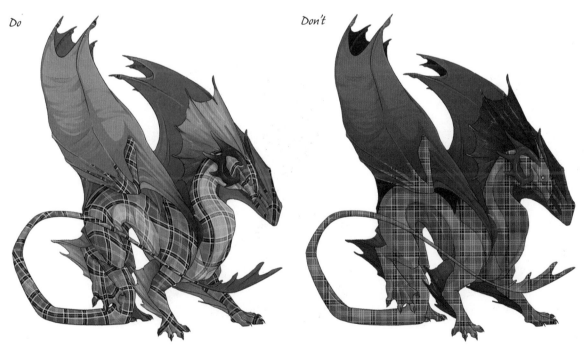

Do

Don't

Pattern Bends Around Form

If you create a pattern, color gradation or marking, remember that it will bend around the surface of your dragon's skin. The dragon is supposed to mimic a three-dimensional creature. Another don't: Making your dragons plaid to begin with.

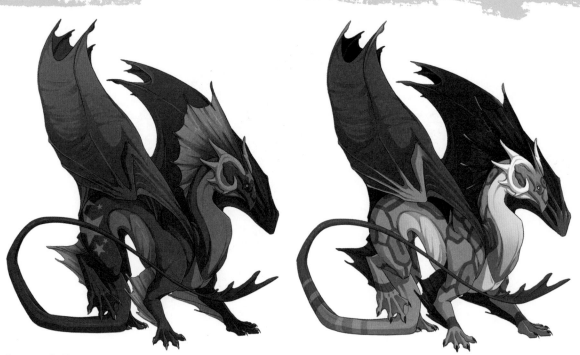

Inorganic Patterns

Geometric markings can be quite fun to play with visually, though this can result in making your dragon look more like it is tattooed rather than born with markings.

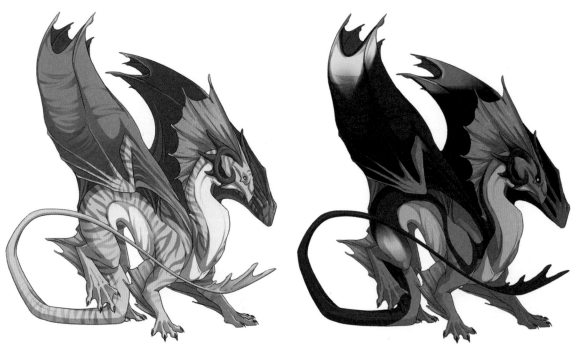

Organic Patterns

If you want to apply an elaborate pattern to your dragon but don't know what to do, existing plants and animals can be a great source of inspiration. The dragon on the left mimics a tiger's stripes, while the one on the right mimics the pattern of a blue tang.

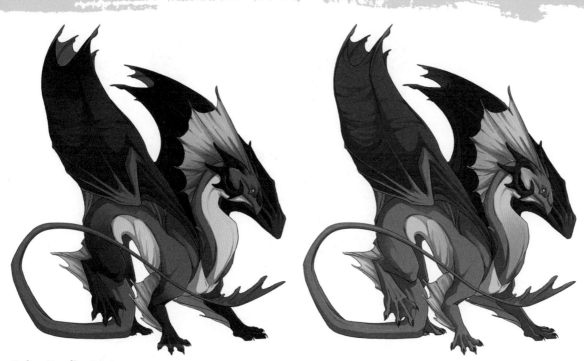

Color Gradients

Gradiating your dragon's color towards its extremities is a strategy you can use to add more life. Color gradients don't have to be on the extremities only, though. You can also create blended spots of contrasting color to add flare.

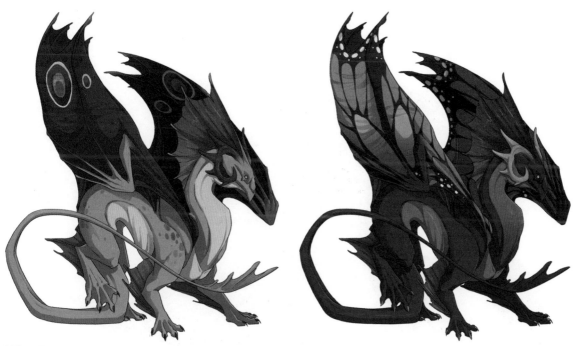

Wing Patterns

Perhaps the markings on your dragon aren't on its body at all, but on its wings. As with body patterns and markings, wing patterns can be borrowed from nature or something you've created from your own imagination.

Bringing It All Together

You can use a variety of patterns, fades, complementary, chromatic and neutral colors in a variety of combinations to create awesome looks for your dragon. All the things we've covered so far are some ideas and general guidelines…just remember not to go overboard.

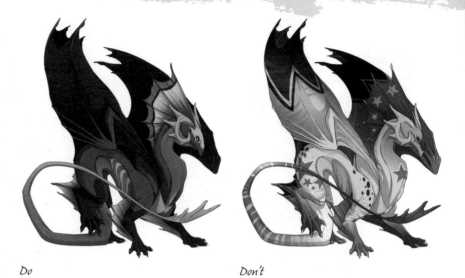

Do

Don't

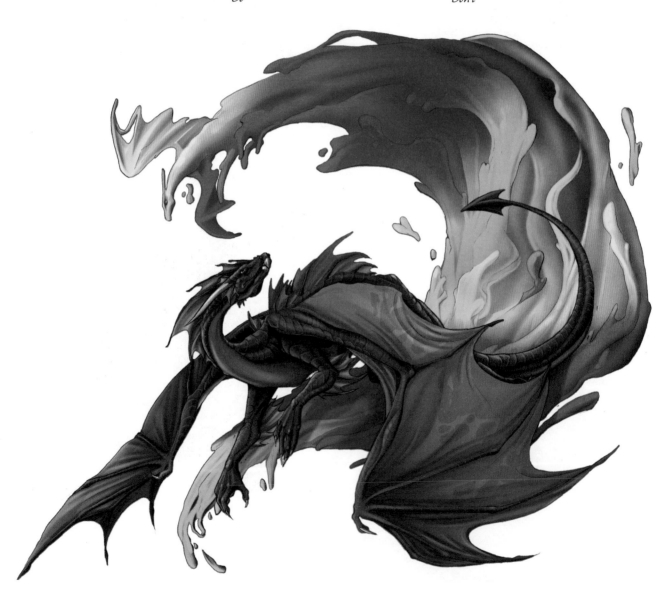

Do's, Not Don'ts

It's time you put what you've learned into practice. Dive in and start coloring with your favorite crayons, colored pencils or markers . We've even left the back of the pages blank so if there's any leakage, it won't mess up your drawings. These pages are meant to be colored!

Eyes Show Nature and Emotion

Your dragon's eye and the ridge above the eye (like an eyebrow) are very important parts of its character.

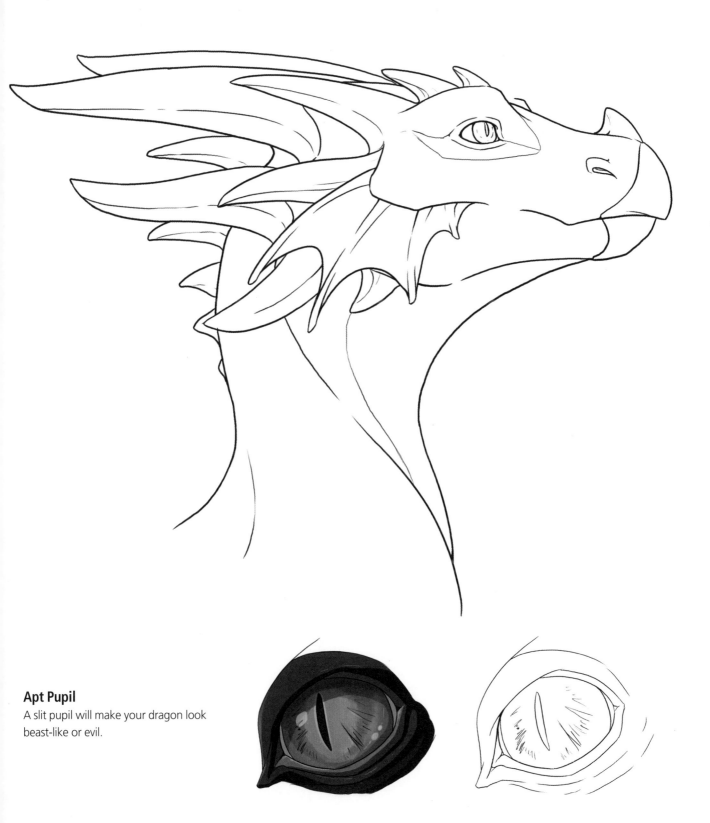

Apt Pupil
A slit pupil will make your dragon look beast-like or evil.

Round Pupil

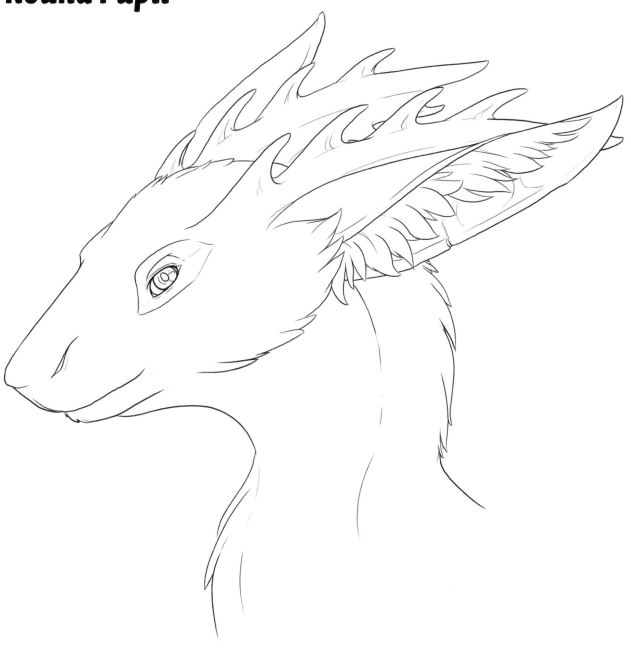

Humanesque
A round pupil will give the dragon a warmer,
intelligent and human-like expression.

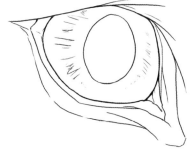

Friend or Foe?

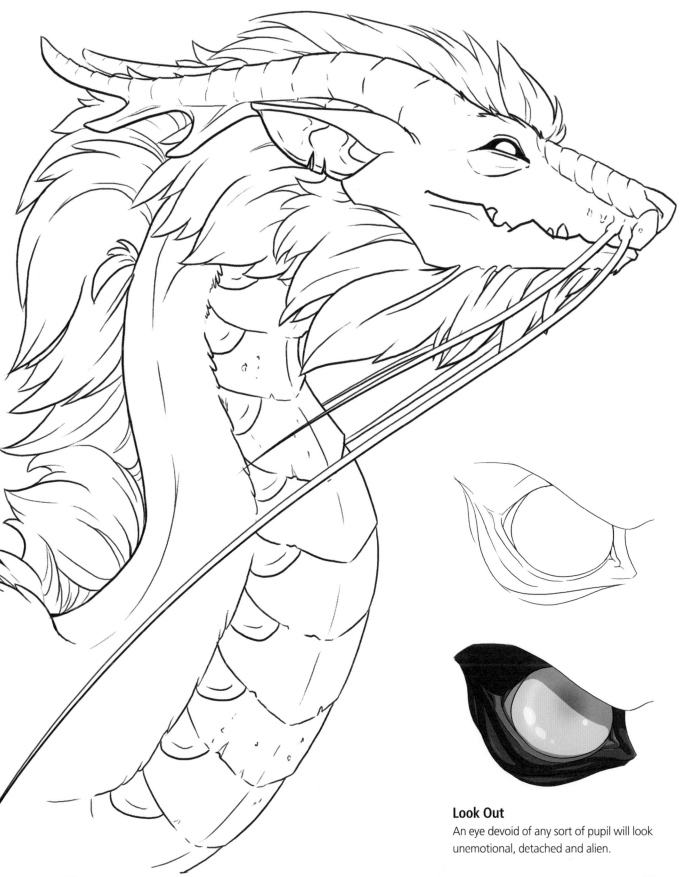

Look Out
An eye devoid of any sort of pupil will look unemotional, detached and alien.

Spiked Horns

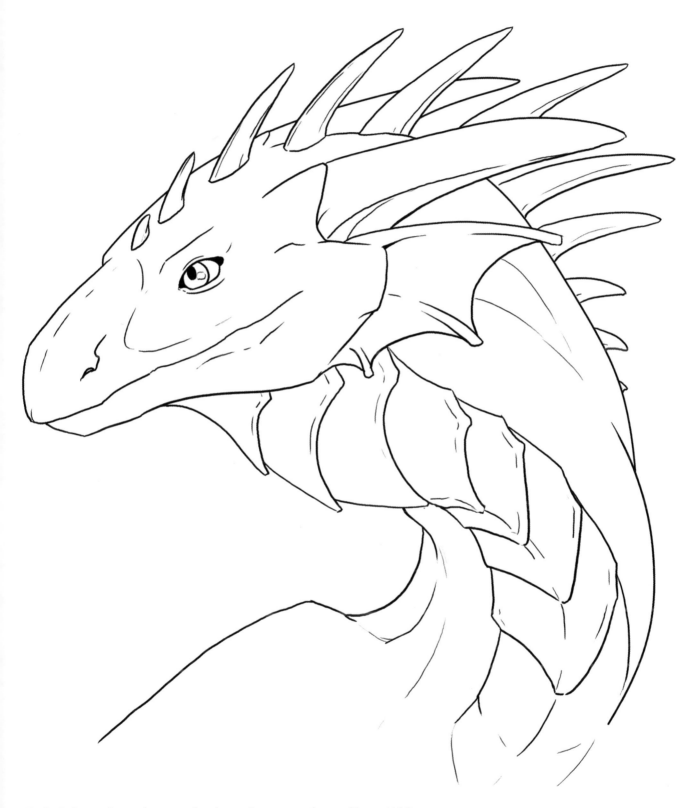

Typically horns do not have much color as they are made up of bone. White, ivory, light brown, gray and black are the most common colors. Use highlights to give the horn a clean, shiny look.

By the Horn

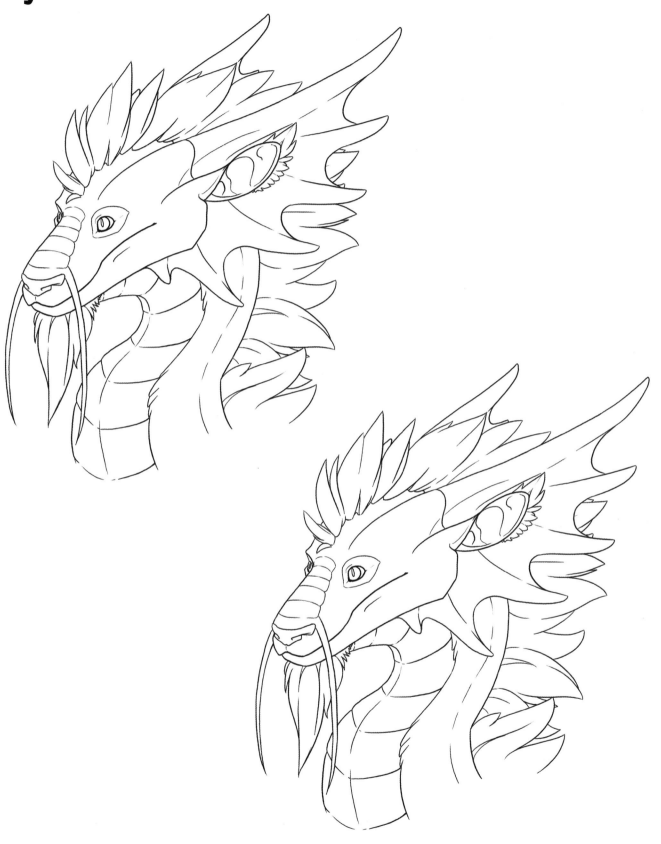

Dragon Shading and 3-D Effects

Dragons appear more realistic when you draw them to look three-dimensional. It isn't as hard as it sounds. You just have to pay attention to darks and lights and how they affect your creature.

Consider first where the light is coming from. This is called the *light source*. Where the light source hits your dragon is the lightest spot, called the *highlight*. The rest of your creature will likely be in some stage of shadow. As you develop your skills at shading the shadow areas, your creatures will look even more fearsome and realistic.

Be Aware of the Light Source

Dragons, supreme though they are, remain solid, tangible objects that follow the same laws as everything else—at least when it comes to the light source. Lighting that comes from a single direction will yield highlights on the surfaces that it hits, and shadows on the areas blocked off from the rays.

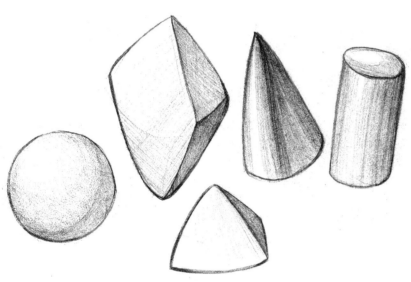

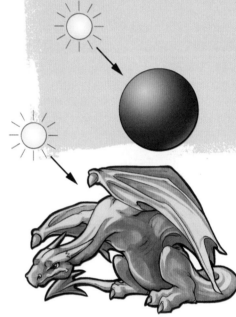

Practice on 3-D Shapes

Polygons, shapes with three or more sides, will often have one side facing the light source. This side will be considerably lighter than those angled in a different direction. Sides that are completely cut off from the light will be very dark, giving you a harsh edge.

With round objects there is no clear definition of where things get cut off from direct light. The answer to this problem is fairly simple: Because there's a gradual cutoff, you will have a gradual shadow with no harsh edges. Figure out where your light is hitting directly. As things move farther away from that point of light, they should get darker.

Color Shading

Remember back how we said that white isn't white? Similarly, light isn't white, either, at least when it comes to the light hitting your dragons. The light reveals the colors in the dragon's scales, and only the brightest highlights may appear bright white (and sometimes not even then).

Shadows aren't pure black, either. Shadows simply show color at its darkest value, so the shaded parts of a red dragon should still retain some red.

Advanced Lesson

Reflected light is a weaker source of light that keeps shadows from going all black. The color of reflected light is made up of the color of the light source, the object reflecting it, and the color of the object itself. Dragons like their treasure, so reflected light is something to keep in mind.

If a dragon is green, the light source is an orange-yellow fire and they're surrounded by gold, what color will the shaded parts of the dragon be? Not black—the colors of the flames and gold will affect the shade of his scales.

This will take some practice, but it's worth the effort!

Eastern Flair
This dragon has a flair for dramatic lighting.

Light and Dark

Sweet Spot

Shaping, even in highlights and shadow, does not have to be 100% accurate. Sometimes, making simple, eye-pleasing shapes results in a better picture than trying to be photorealistic. Ovals of light and blocks of shadow that become shapes of their own move the viewer's eye through a picture.

Sugary Sweet
Look at your image as a whole and make sure there are lots of these "sweet spots" in the places you want your viewers to pay the most attention to.

Shadow and Light

Highlights and shadows give dragons form. Lighter colored highlights show off shiny, reflective skin.

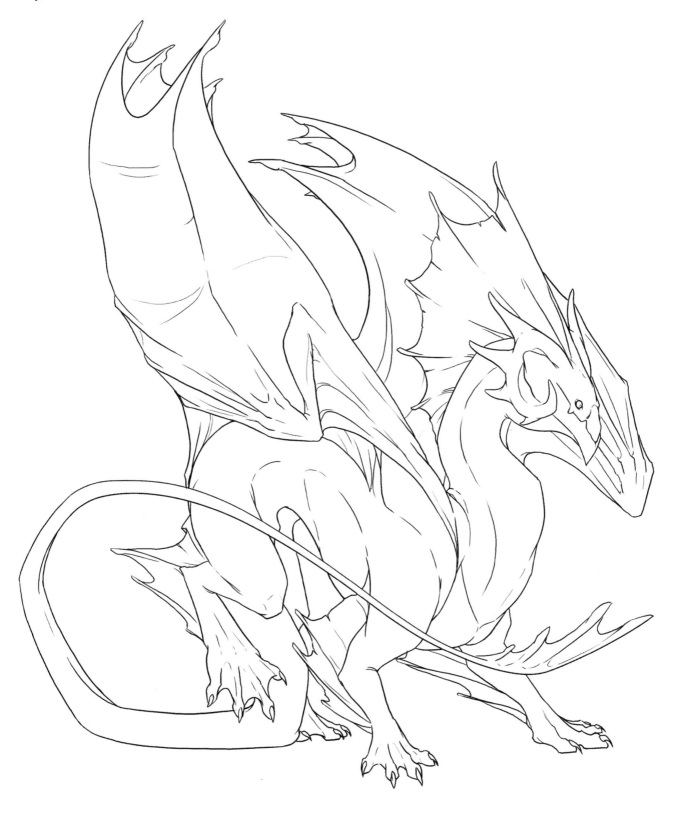

Tidecaller

Consider where your dragon lives. "Underwater" is a broad term. A dragon that dwells miles beneath the surface of the ocean would have to be able to withstand great pressure and would likely have adaptations to enable it to live without light. A dragon that dwells in a tropical reef will be different than one who dwells in the icy waters of the north.

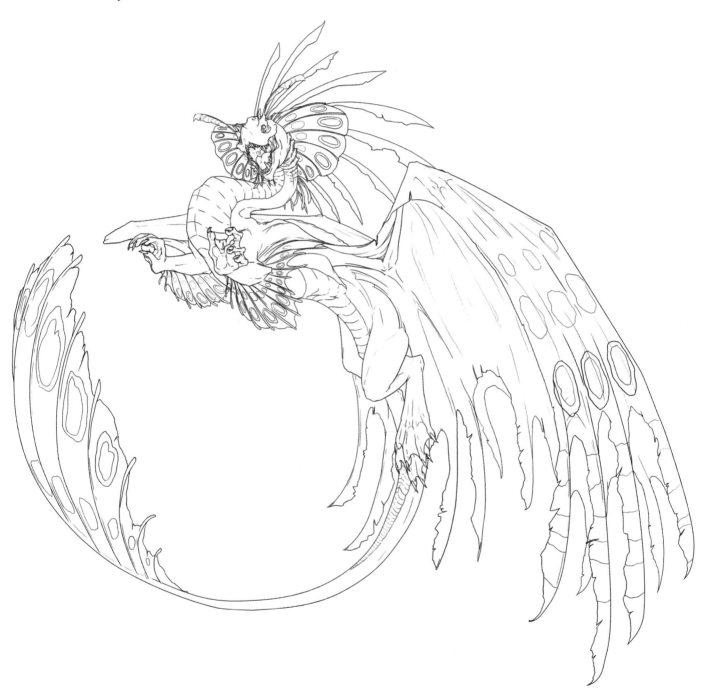

Watery Lair
Color your sea dragon to mimic existing fish and marine life such as the markings of an orca or the patterns of an exotic fish.

Sea Dragon With Mermaid

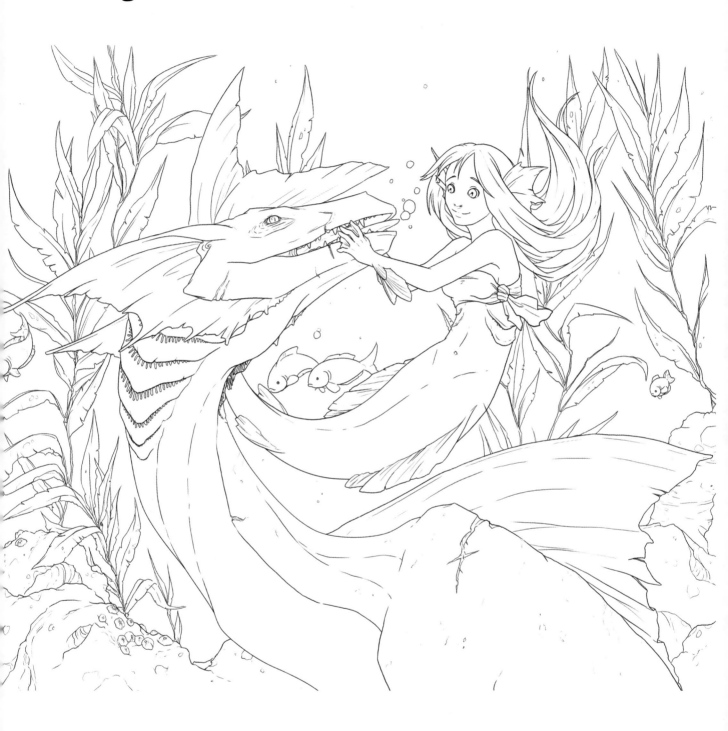

Environmentally Friendly

You can display your dragon as is, or place him in an elaborate underwater environment such as a coral kingdom, a deep sea space full of glowing creatures, or an aquatic graveyard.

Head to Tail

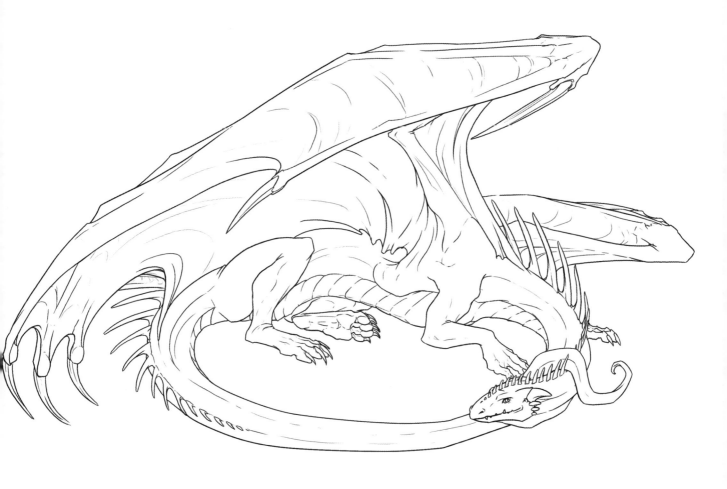

Lines of Motion

Within dragons there exists harmony and splendor. That inner balance is based upon the infernos raging within our being, and also upon the line of motion. A line of motion shows the general flow of the creature and becomes an excellent base on which to build the rest of your dragon.

Crest Head

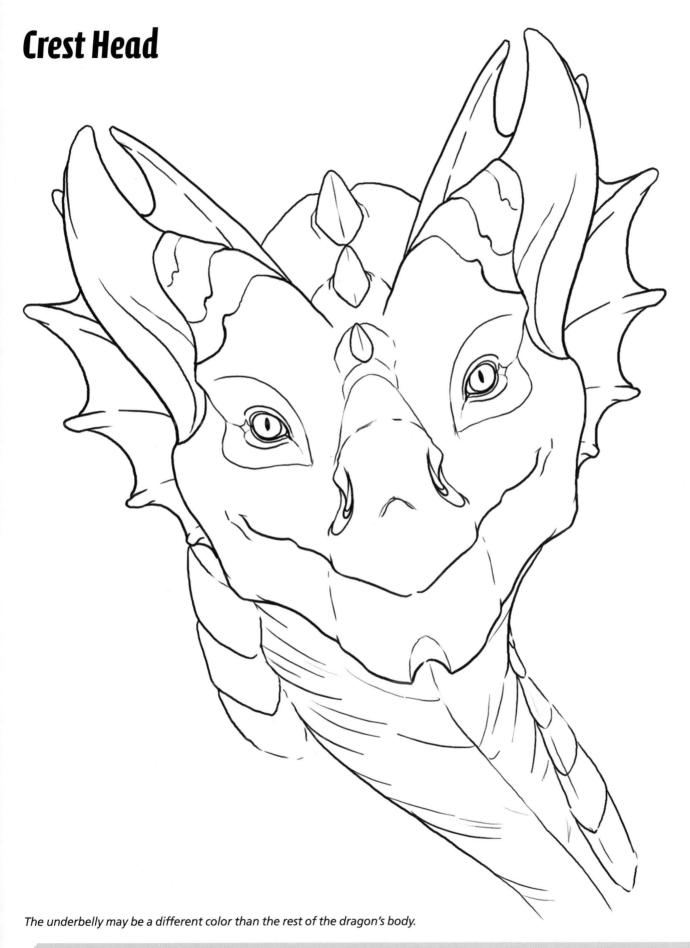

The underbelly may be a different color than the rest of the dragon's body.

Scales

Once you have the form down, you can begin detailing pieces of it with fine scale work. Scales and patterns are a wonderful way to give your dragon personality to differentiate it from other wyrms. You can scale your dragon the same way all over or apply different scales and patterns on different areas of its body. You may want to give the underbelly a different texture from the back, for example.

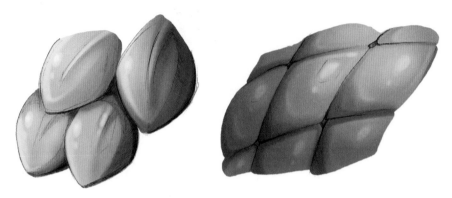

What Kind of Scales?

The scales of your dragon can either lay one on top of another or butt right up next to each other. The choice will yield two very different results, but in both cases, you will need a system for placing them down so that you don't end up with a chaotic mess scribbled across your lovely beast!

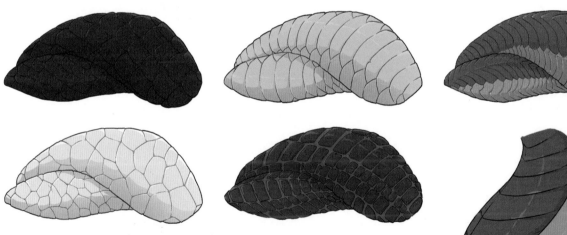

Scale Patterns

Putting scales and plating on your dragon allows for further design customization, and the type of scales you use affects the final look. You can use scales all of the same type or combine many different types of scale for an elaborate pattern.

Scale Patterns

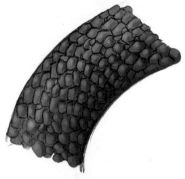

Pebble Approach

These scales are roughly the same size and shape for a simple, fairly uniform scale texture.

Pebble Shadows and Highlights

Each scale needs a small shadow and highlight. The whole form of the dragon will have shadows and highlights as well.

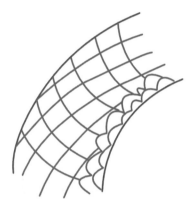

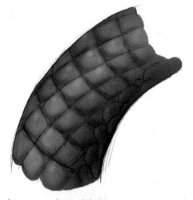

Curved Lines

This pattern features uniform curved lines that wrap around the form to create diamond-shaped scales.

Scales are placed right against each other for a smoother appearance than overlaid scales.

Curved Shadows and Highlights

Each scale needs a small shadow and highlight of its own. Remember to include the shadows that wrap around the entire form.

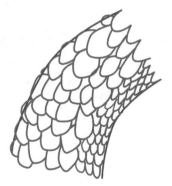

Varied Scales

This pattern has rows of U-shaped scales of different sizes.

The scales should follow the flow of the creature. In most cases, they should lay pointing toward the far end.

Underbelly

Make larger scales really pop out and cast a shadow on the underbelly.

Don't forget the shadows and highlights.

Scaled Dragon

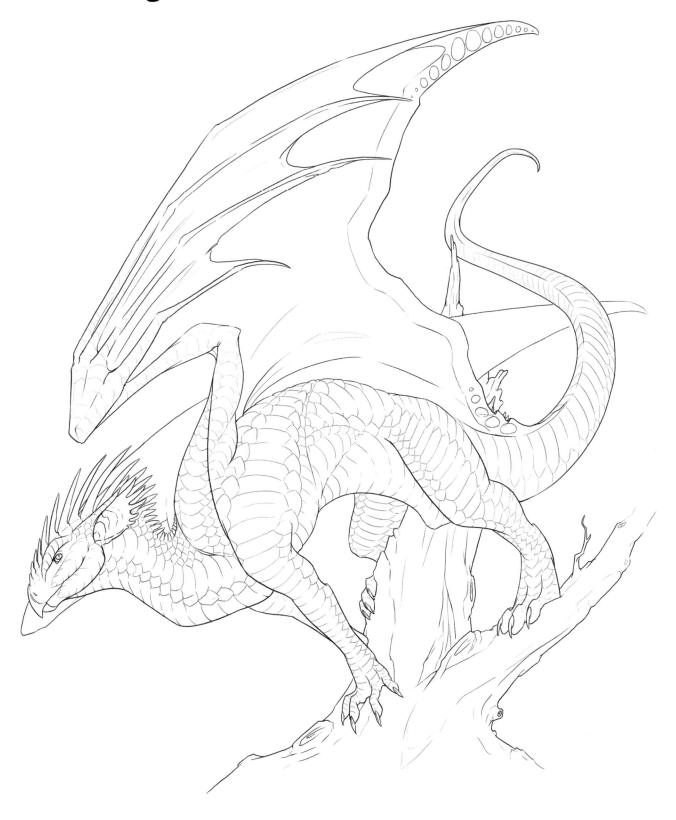

The Big Picture

Light the body as a whole before you create shadows for the scales.

Flying Dragon

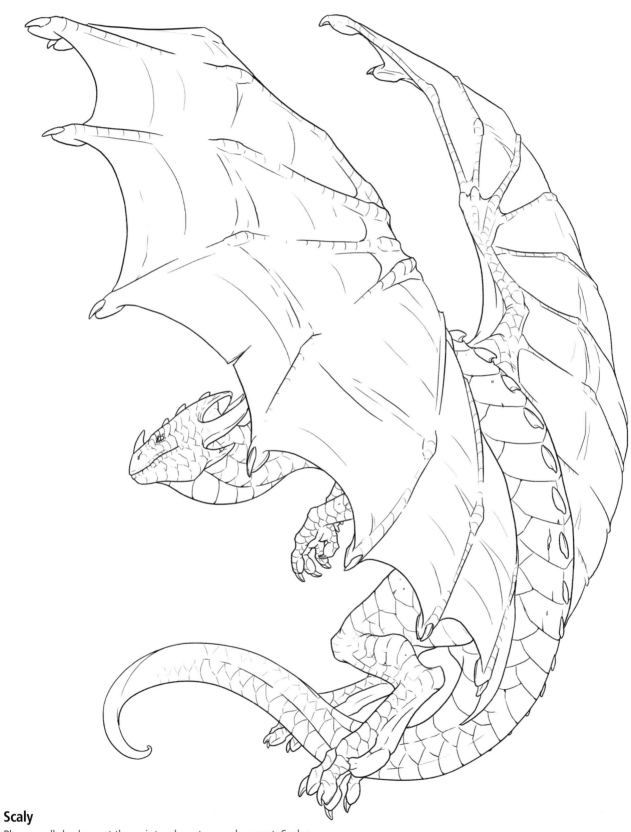

Scaly

Place small shadows at the points where two scales meet. Scales
are small, relatively flat objects, so they won't cast huge shadows.

Feathers

Though not a common choice for most dragons, feathered wings are still found in many fantastic creatures such as the griffin, phoenix and Pegasus. Feathered wings are made up of primary feathers and contour feathers. The primaries are the main flight feathers that stick out along the edges of the wings. They'll need more detail. The contour feathers provide overall shape for the wing. Most of the time you can represent these without a lot of detail.

Some feathers are perfectly smooth along the edges while some have a little bit of tatter. This is because the ribs that make up the soft portion of the feather zip to become a single form. Where you see the tatter is where the "zipper" has been ripped from use.

When placing the wing on your creature, take into account what happens when feathers transition to skin or scales. You may want to toss in a bit of feathery fuzz that fades out into skin across the body of your dragon to make the wing seem more natural.

What's Underneath
A wing without feathers looks like something you might cook for dinner. The structure of the wing is formed by a shoulder-elbow-wrist combination. It's over this form that feathers grow. Keep this in mind when starting the wing.

Feather It
Work out from the center of the feather with sweeping lines.

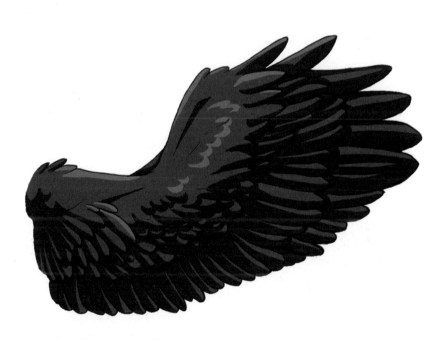

Layered Feathers Form a Wing
Begin a feathered wing just as you would any other wing. Then add the feathers as you would scales. Feathers usually consist of three basic layers. The layer closest to the top of the wing has shorter, rounder feathers. The next layer is in a neat row and is formed of longer, more sharply edged bits. The edge of the wing consists of primaries.

Fur

A coat of fur or wavy mane can make your dragon softer and more appealing. Simplify your art by using line and shadow to give the illusion of fur all over without having to go crazy actually drawing those thousands of individual hairs!

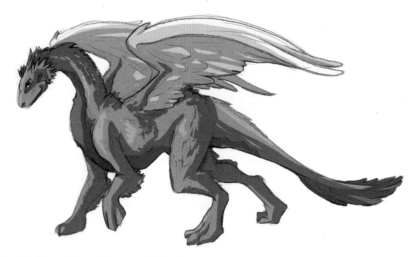

Fur Reflects Your Creature's Heritage

Dragons that live in icy climates would greatly benefit from a fine fur coat! It makes them look rather charming, too. This blue-furred dragon is all cuteness and fluff until you get close enough to see the rows and rows of adorably sharp teeth.

Simplify to Fool the Eye

Draw tufts of hair along the edges of all your shapes to make it appear that everything within those shapes is furred as well.

Fur Shapes and Direction

Keep your fur flowing in the general direction of the shape it is on. In general, the shorter the fur is, the fewer individual shapes you need to draw to get across the texture of the creature. Longer fur requires more detail.

Sitting Feathered Dragon

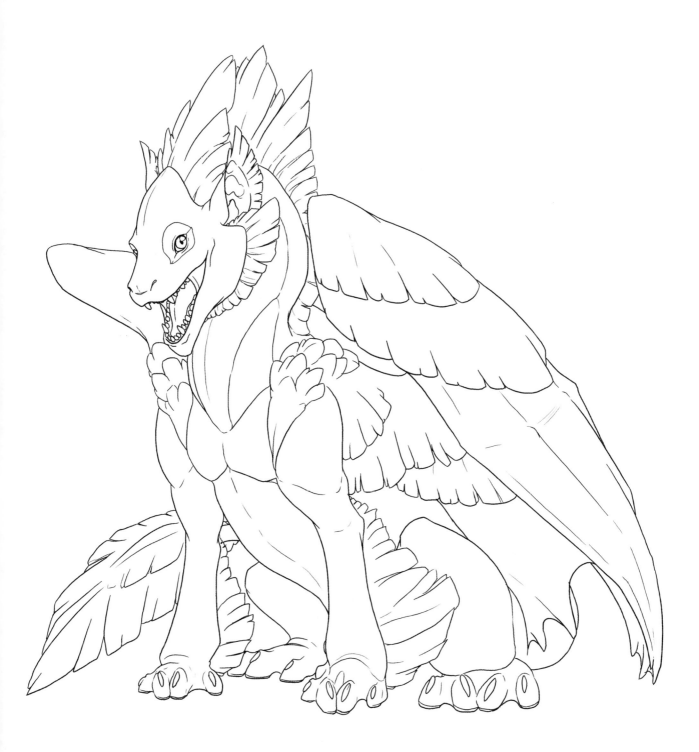

Birds of a Feather

The feathers can be colored and patterned after those of a bird,
or they can be your own unique color scheme.

A Frills Kind of Creature

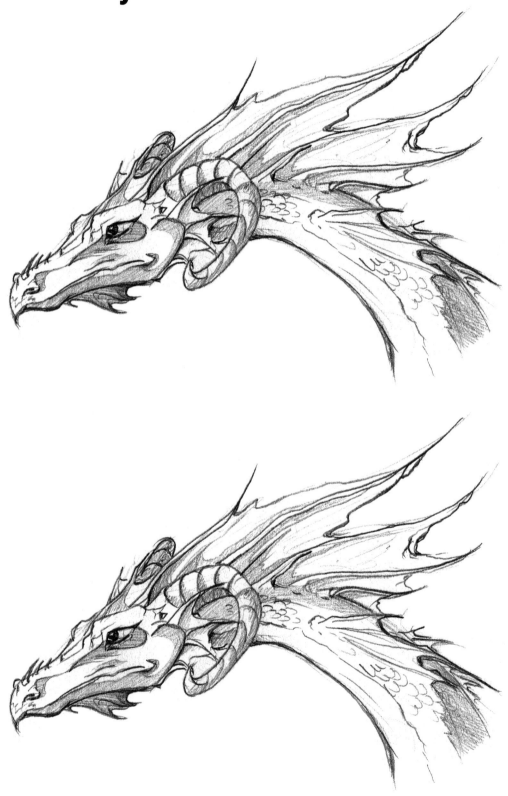

Frills can be the same color as the dragon's body or they can have a delicate skin of a different shade that sets off the color of your dragon.

Lung Dragon

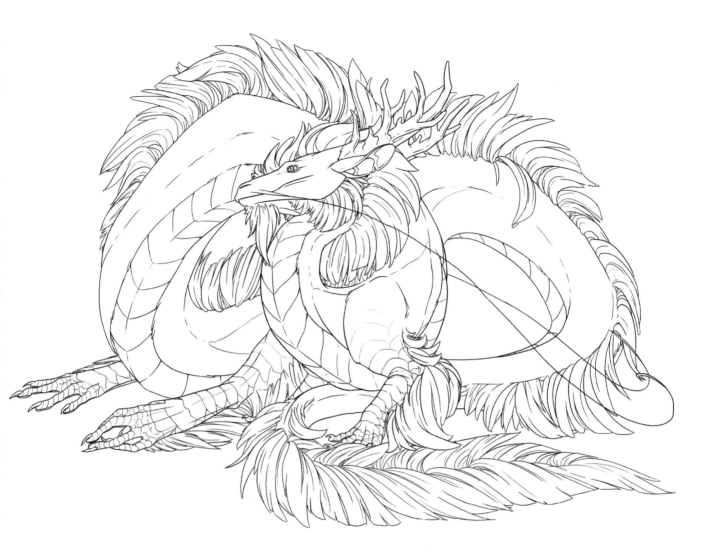

Good Omens

Unlike its often monstrous medieval Western cousin, Eastern lung dragons are often portrayed as benevolent creatures, and a favorable sign for those lucky enough to encounter them. The lung dragon is a long, serpentine creature with the scales of a carp, the claws of an eagle and the horns of a deer. They are able to soar through the heavens without the use of wings—a magical feat indeed.

Fight For Life

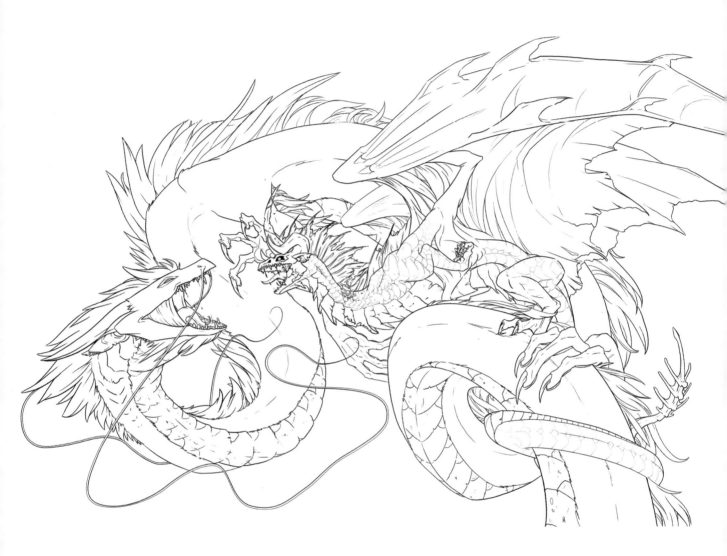

Mesoamerican Dragon

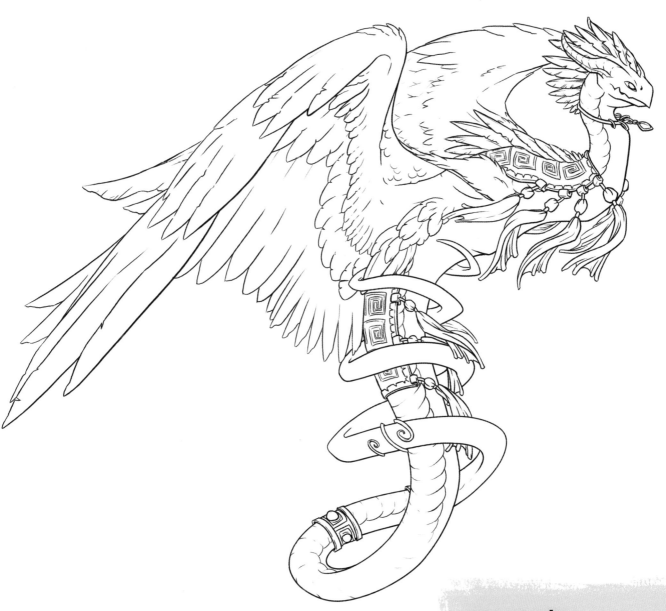

Fancy Feathers

The feathered serpent can be a fun dragon to color. Its long body can twist and cling across your canvas. Your serpent can be just as compelling airborne as it is looping its coils over the branches of a tree. Consider adding accents to your serpent such as elaborate jewelry, tassels and gold decoration.

Of a Feather

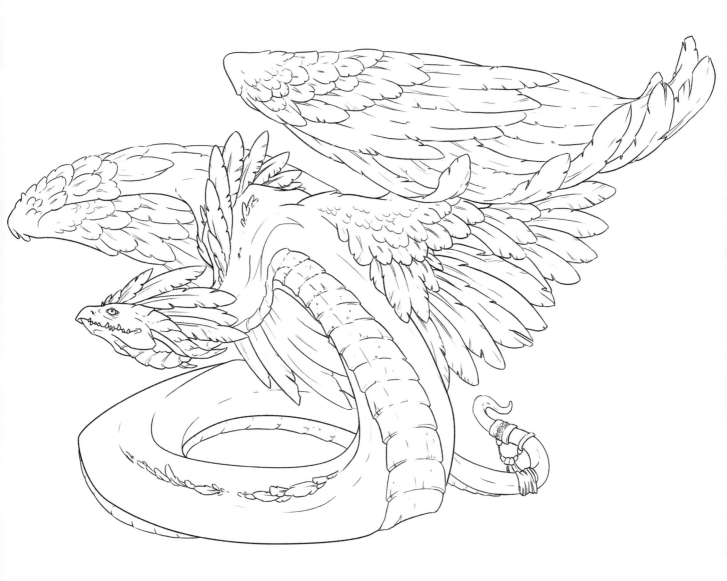

Shading Techniques

You can use different types of techniques to create shading and contours. The techniques are in black and white, but if you build up layers using different colors, you open a whole new world of possibility.

Scribble—Swirl your pencil in overlapping circles.

Crosshatching—Lay hatch marks, one over the other.

Stipple—Place dots close together or far apart.

Hatching—Place short lines close together or far apart.

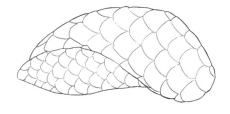
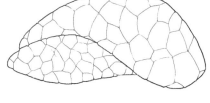
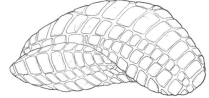
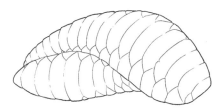
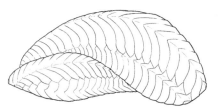
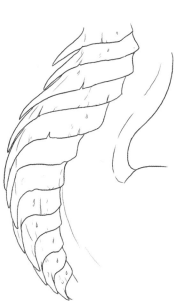

Practice

Try these techniques on these scales to compare and contrast.

Shading Styles

Depending on whether you want more realistic-looking dragons or more stylized beasts, you can choose between two different types of shading.

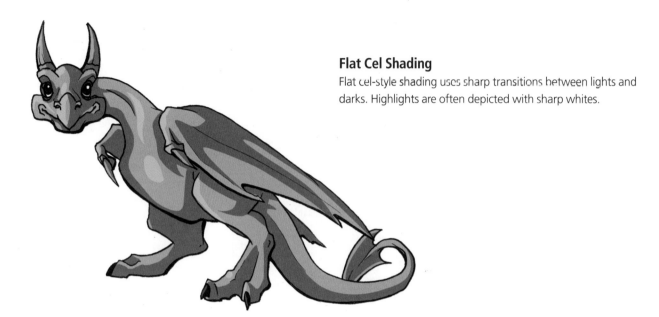

Flat Cel Shading

Flat cel-style shading uses sharp transitions between lights and darks. Highlights are often depicted with sharp whites.

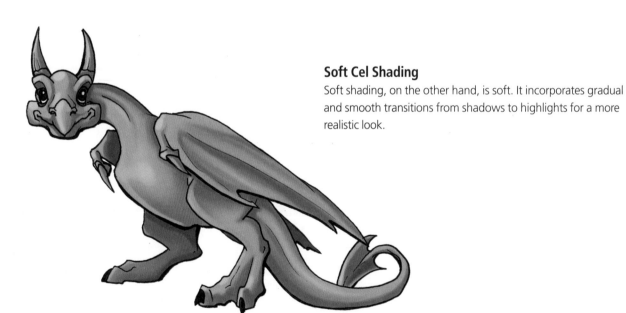

Soft Cel Shading

Soft shading, on the other hand, is soft. It incorporates gradual and smooth transitions from shadows to highlights for a more realistic look.

Drake

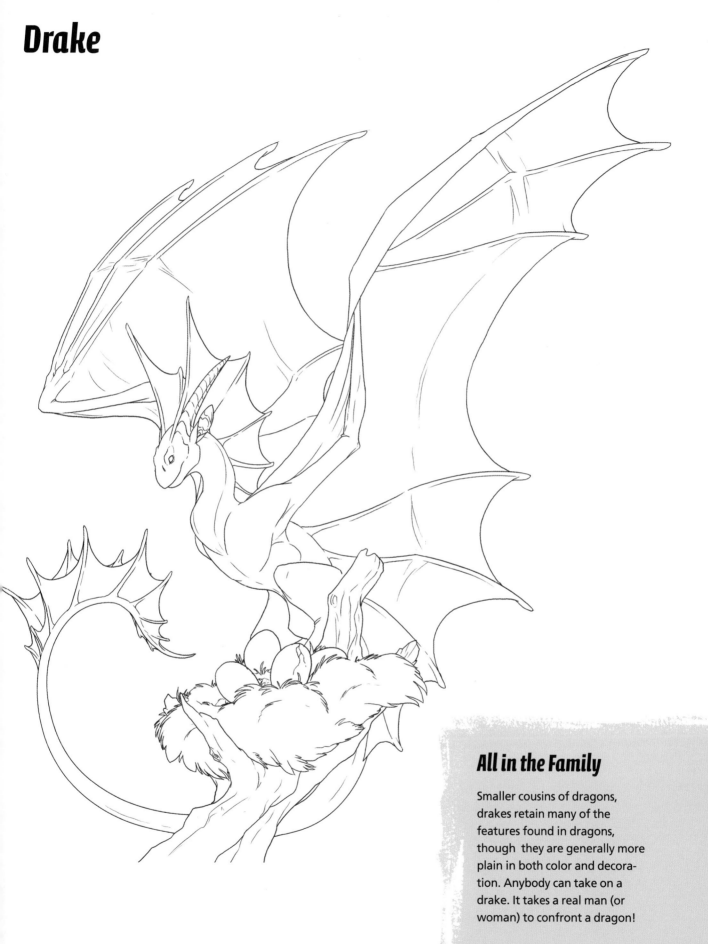

All in the Family

Smaller cousins of dragons, drakes retain many of the features found in dragons, though they are generally more plain in both color and decoration. Anybody can take on a drake. It takes a real man (or woman) to confront a dragon!

Hatchlings

Your hatchling may share the exact same coloring as the dragon it will turn into, or it may be a duller version of the color to help camouflage it for protection while it is young and vulnerable.

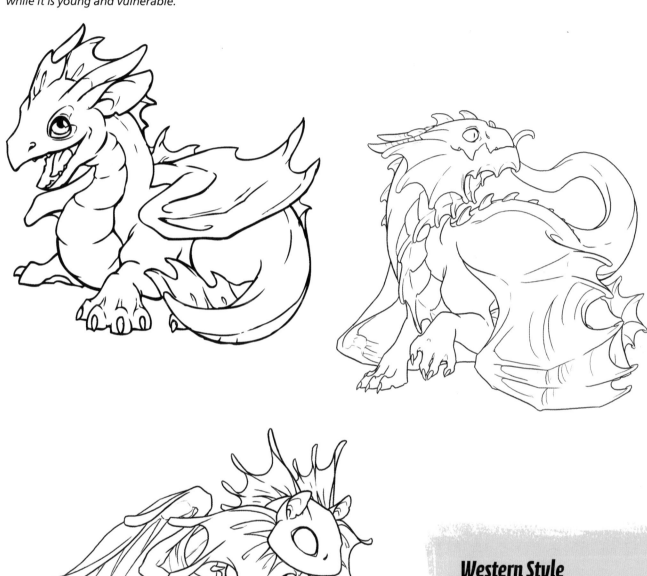

Western Style

Western dragon hatchlings often walk on four limbs and have a pair of batlike wings on their backs. They may not yet sport a full set of horns on their heads, but these grow in with time. They may not be able to breathe fire at this early age, but rest assured that when they grow up, they will go from being little terrors to being...large and terrible!

Horned Dragon Head

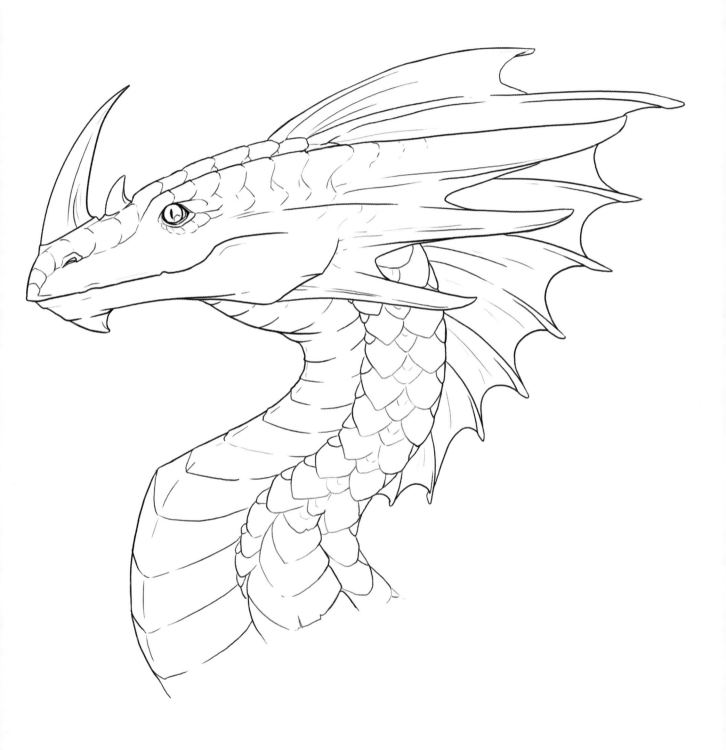

Place your dragon in an environment that suits him. You can leave the horns bone-white or pitch-black, or make them a color that complements your dragon's scales.

Biped Dragon

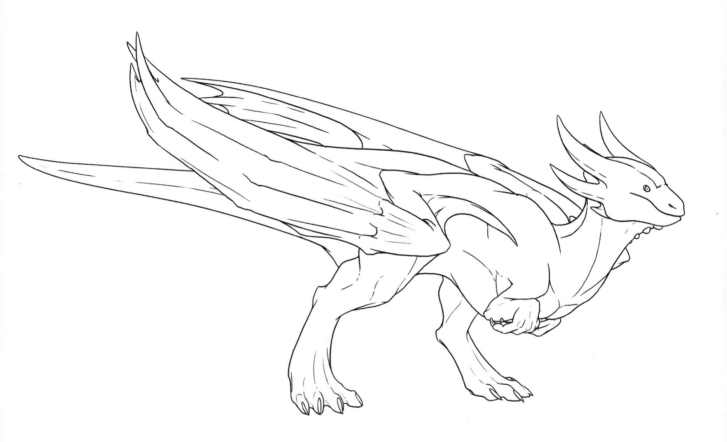

Drawing an arm or a wing without any anatomy detail will leave your creature looking flat. Add biceps, triceps, dragonceps, awesomeceps and excessiveceps to make your drawing pop off the page.

Stubby Leg Dragon

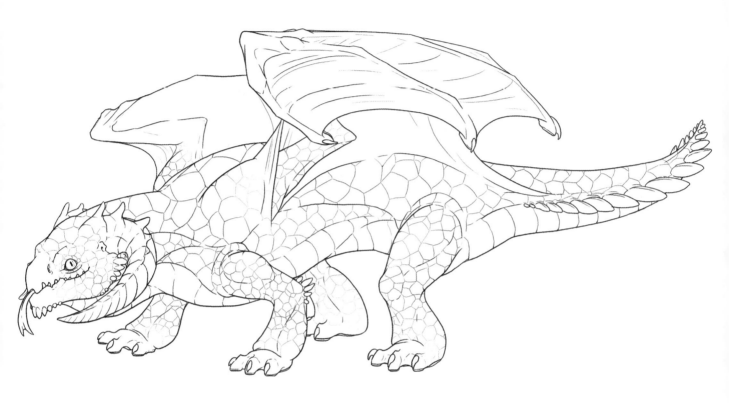

Dragon, Ink

A ballpoint pen will give you a finer, more varied ink line than markers, but watch for smudging! Some ballpoint pens leave unequal amounts of ink in a line, causing much grief later on. Markers are not always the best solution either because they are very susceptible to bleeding. Many art stores carry disposable technical pens that are ideal for starting out with inks. They are fairly cheap, come in different colors and are easy to use.

Stepping Out

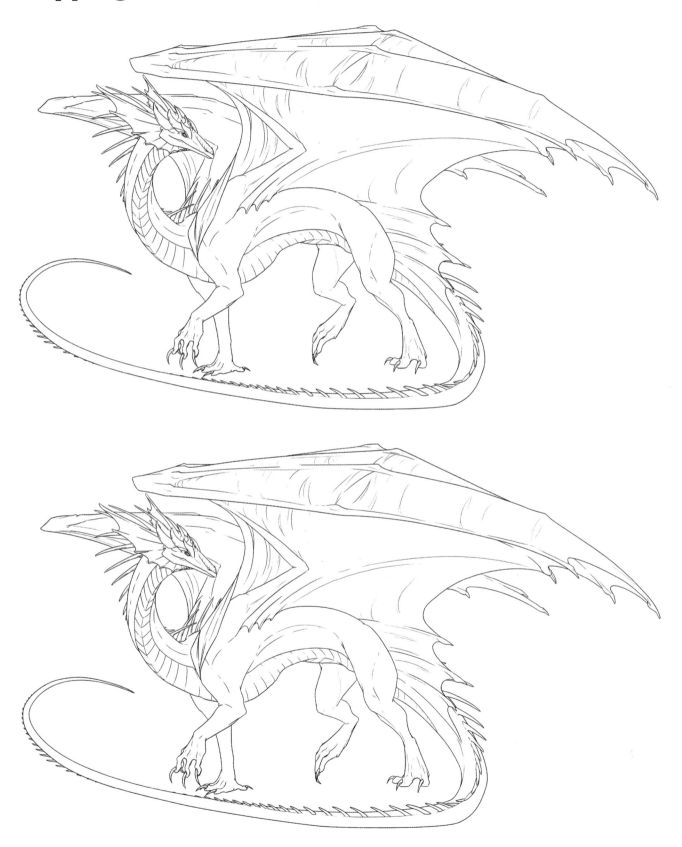

To the East

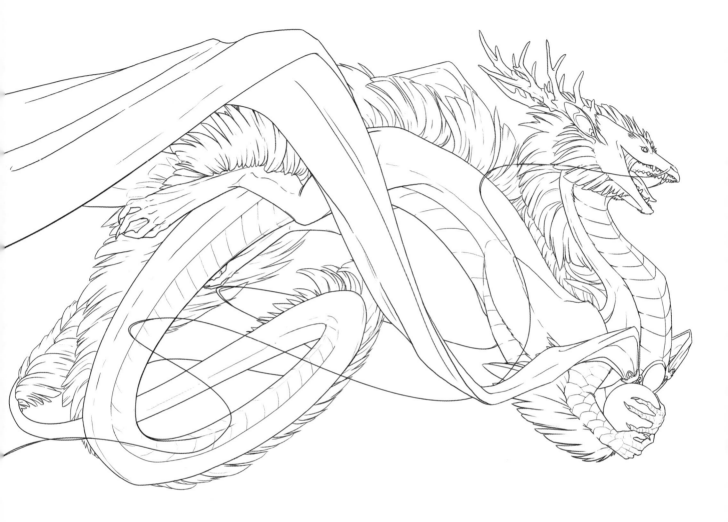

Feeling Lucky?

Unlike their Western Counterparts, Eastern dragons are often benevolent beings. According to Chinese mythology they come in five types:

- *Celestial* dragons guard the gods and emperors.
- *Spirit* dragons control the wind and rain.
- *Earth* dragons guard the rivers and seas.
- *Treasure-hoarders* guard...hordes of treasure... Hmmm.
- *Imperial* dragons are, well, imperial. These dragons have five claws instead of the standard four. And no one but the emperor was allowed to wear this type of dragon on penalty of death!

Eastern Dragon Hatchling

Eastern dragons have an elongated body, so an Eastern baby will have a body that's much longer than a Western dragon, but not quite as long in proportion to its head as an adult.

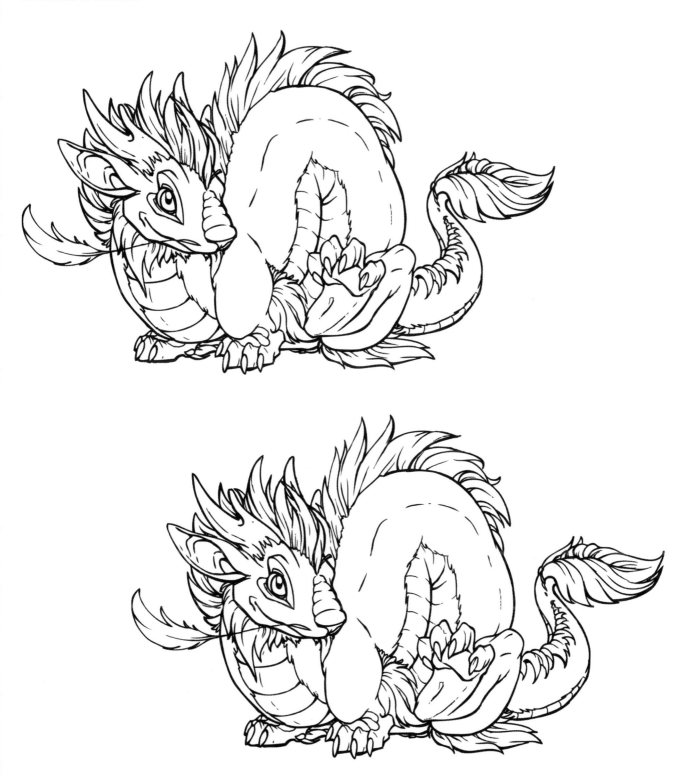

Spirit Dragon

Clouds and rain may be an appropriate setting for a spirit dragon.

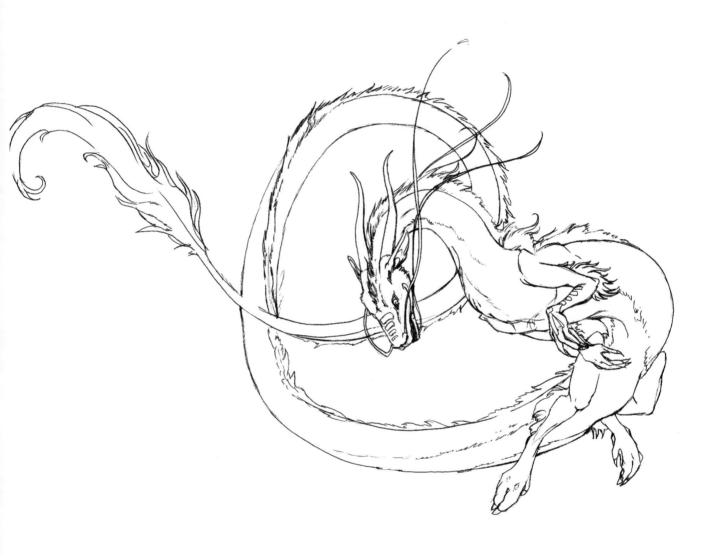

Avoid It

Your poor dragon is floating in a white void! You've already put this much time into it, why not go all the way and add a background? Your dragon deserves it…doesn't he?

Western Dragon

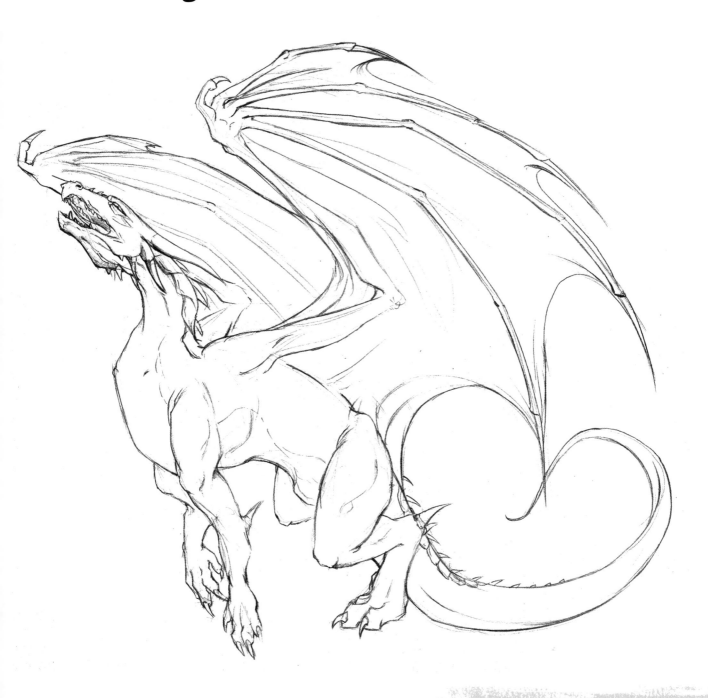

Formidable Foe

Western dragons are more monster-like than their Eastern cousins. Most are not benevolent creatures and are certainly nothing a mere human would want to tangle with!

Color With Care

Color has a lot to do with a dragon's personality and place in the world. Consider this before diving in headfirst with the first crayon you pull from the box. Red will give you a creature of flame and violence, black leans toward dark caves and the undead, while a white dragon lends itself more to ice and magic. Blue brings to mind storms, and gold brings treasure and wisdom. Green is, of course, the best color choice. Green dragons are the most cunning, intelligent, majestic, glorious and fearsome of dragonkind.

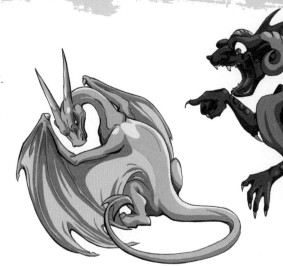

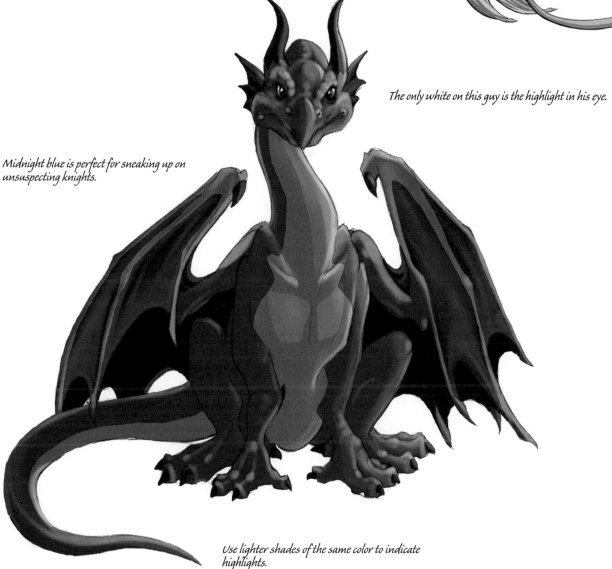

Midnight blue is perfect for sneaking up on unsuspecting knights.

The only white on this guy is the highlight in his eye.

Use lighter shades of the same color to indicate highlights.

Wingfold

Webbing can be a subtle shade of the main color of the dragon, or it can be the complete opposite, a complement to set off the brilliant hue of your dragon.

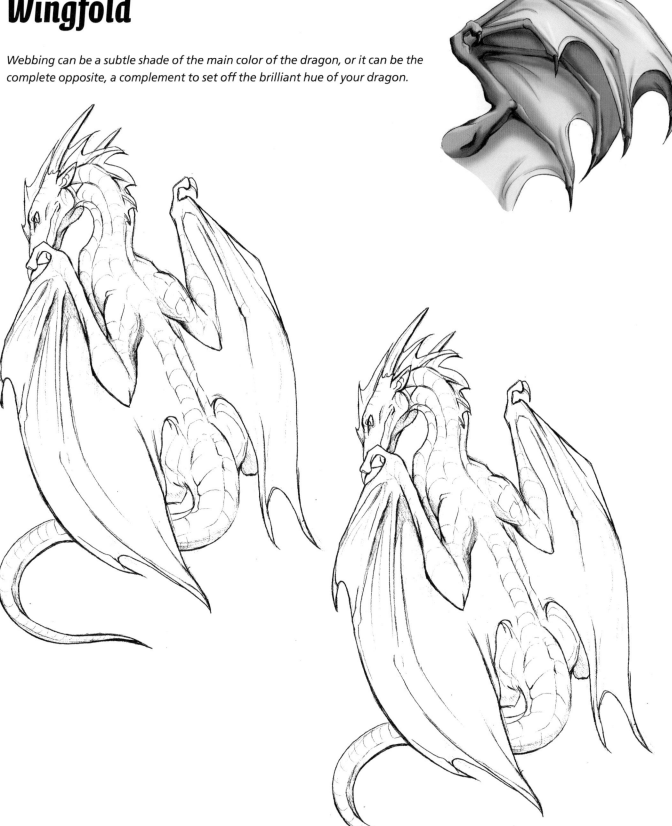

Tattered Wings

Talon

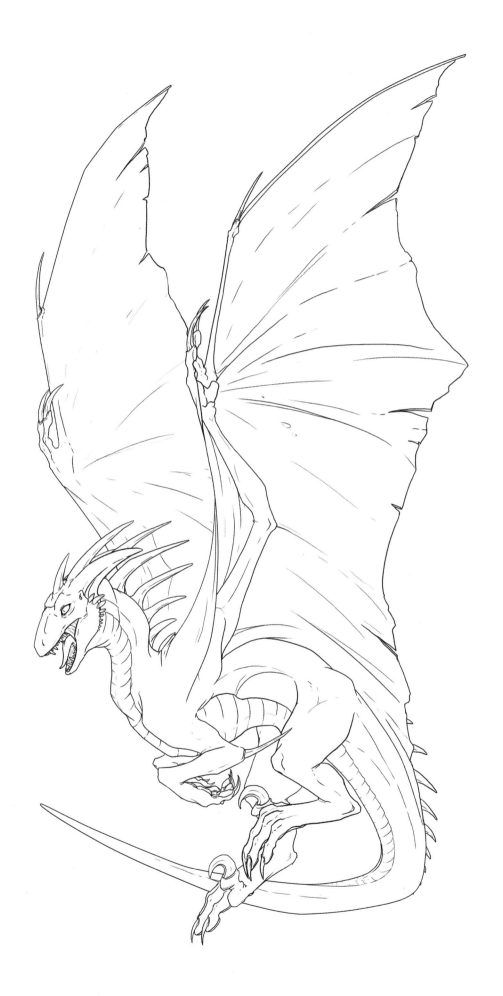

Omni

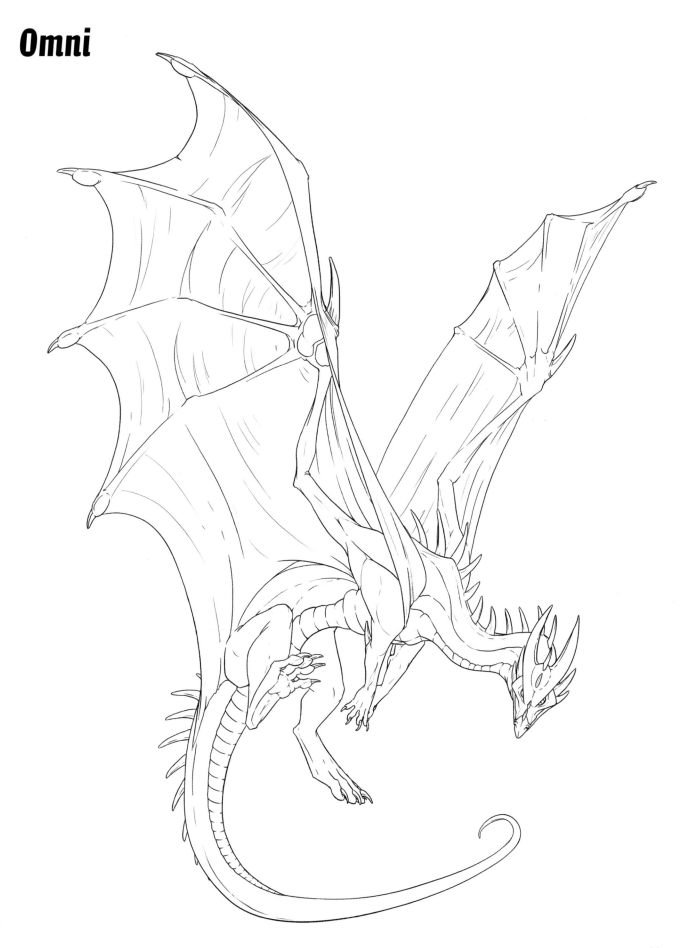

Frost Dragon

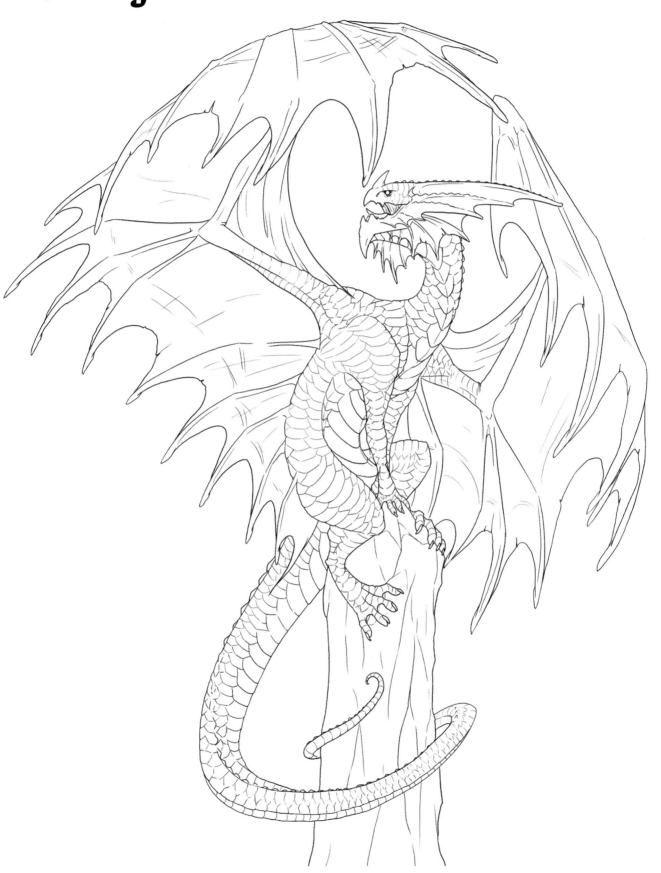

Fiery Finery

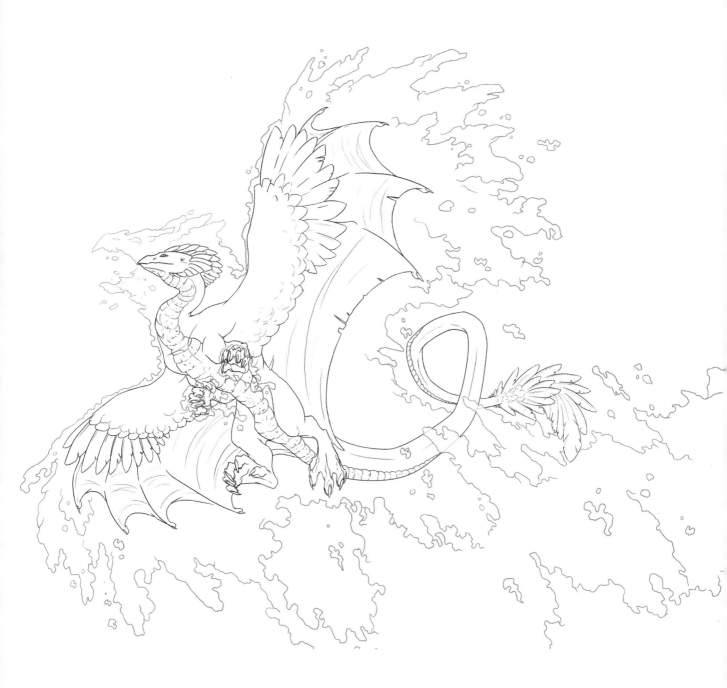

It's a Bird, It's a Plane, It's a...

This dragon's feathers can be colored and patterned after those of a bird, or they can be your own unique color scheme. Add a plume of fire or smoke.

No Need for Matches

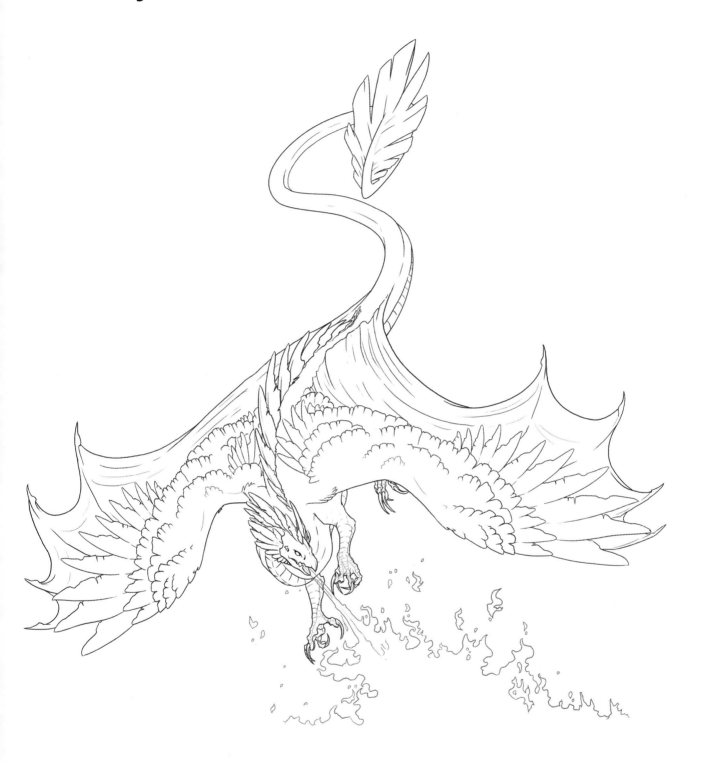

Dragon Rider

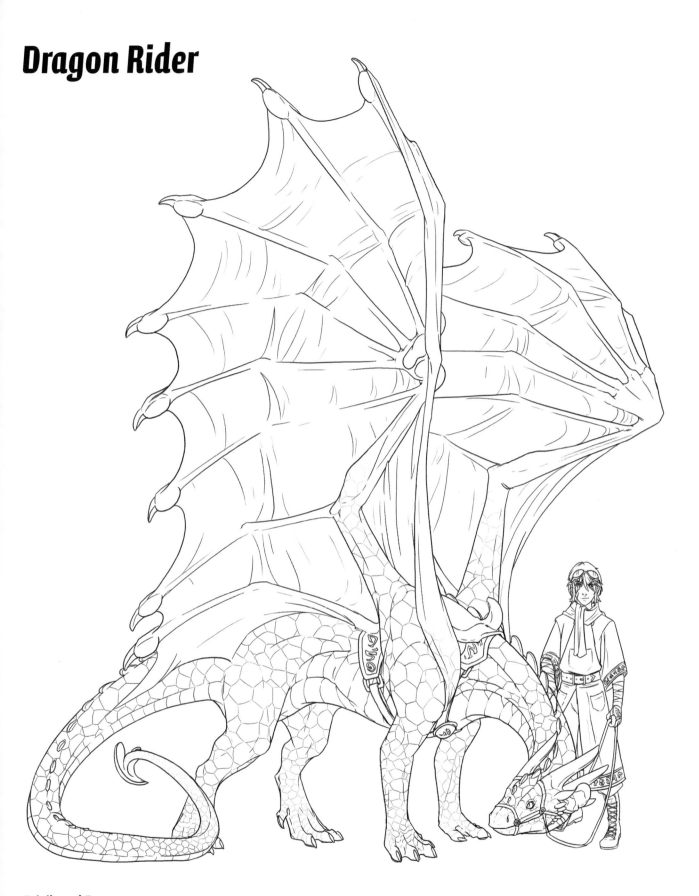

Privileged Few

Not all dragons will allow a smelly human on their backs as they soar through the skies.

The few that do will often form close bonds with their two-legged companions.

Fairy Dragon

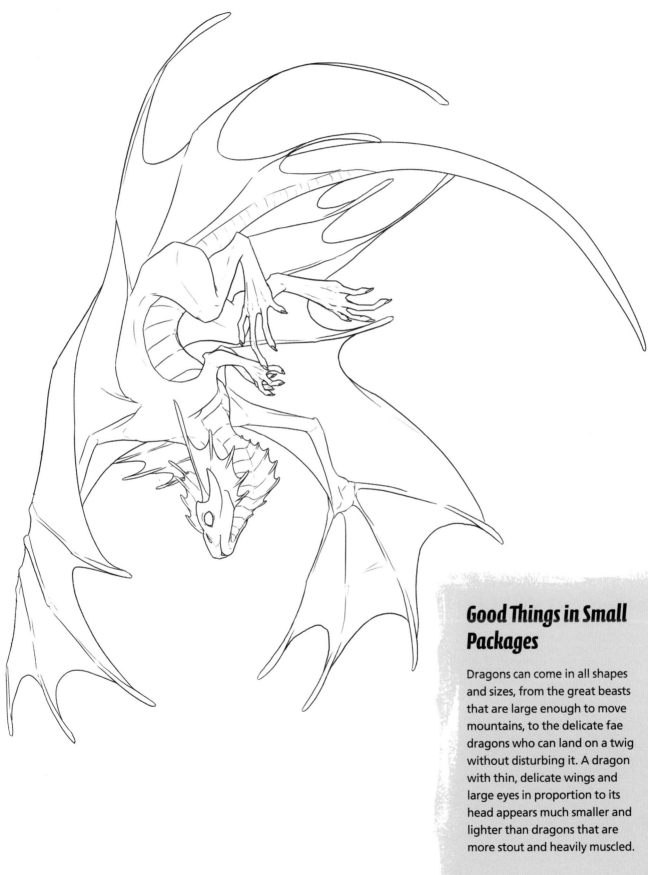

Good Things in Small Packages

Dragons can come in all shapes and sizes, from the great beasts that are large enough to move mountains, to the delicate fae dragons who can land on a twig without disturbing it. A dragon with thin, delicate wings and large eyes in proportion to its head appears much smaller and lighter than dragons that are more stout and heavily muscled.

Kirin

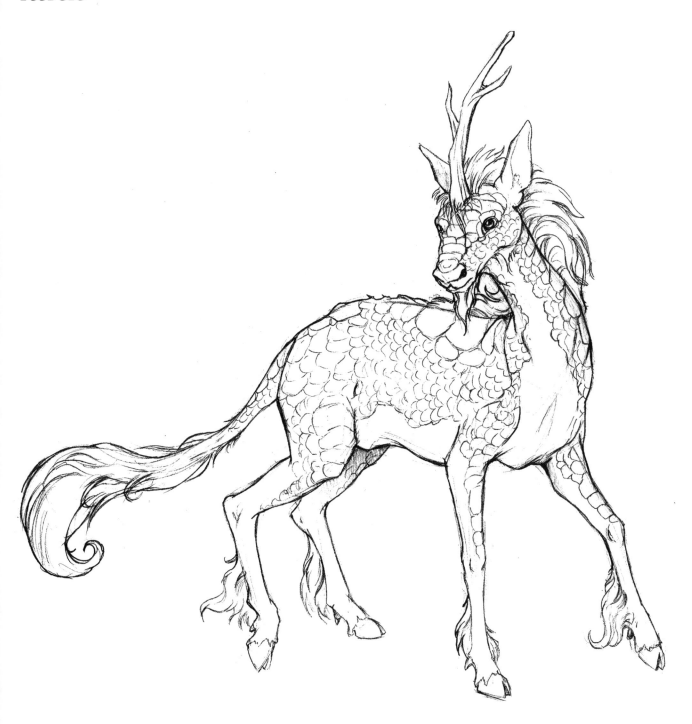

Dragons are not all that there is to fantasy. Thousands of other creatures populate the mythical universe! From wyverns, to unicorns, to the phoenix, these fantasy critters are incredibly fun.

Gargoyle

Stone sculptures do not have paper-thin membranes or delicate feathers, so it follows that when the creature comes to life, the wings don't magically become delicate, wispy things.

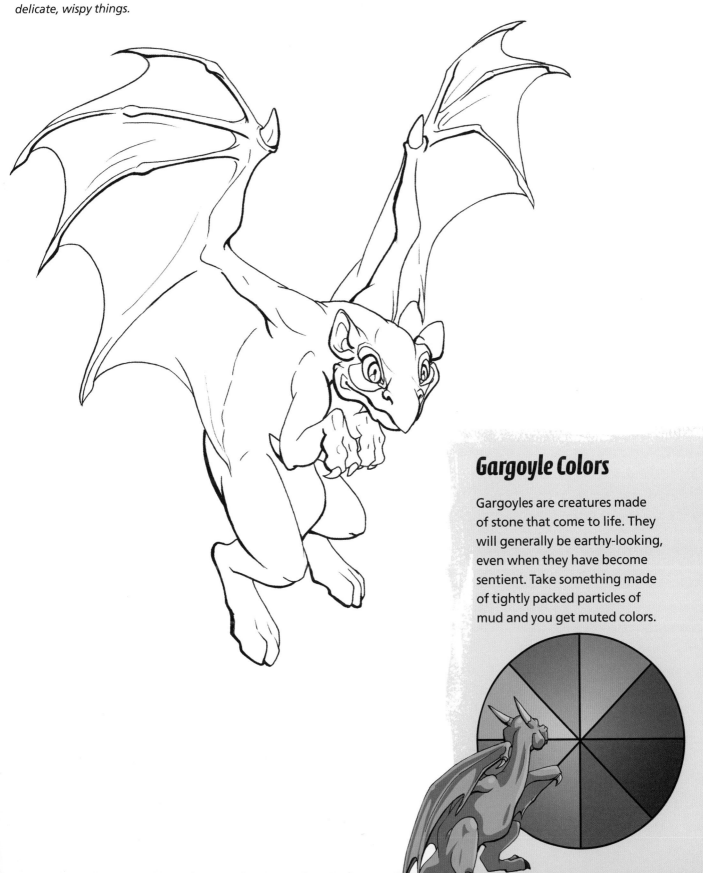

Gargoyle Colors

Gargoyles are creatures made of stone that come to life. They will generally be earthy-looking, even when they have become sentient. Take something made of tightly packed particles of mud and you get muted colors.

Wyvern

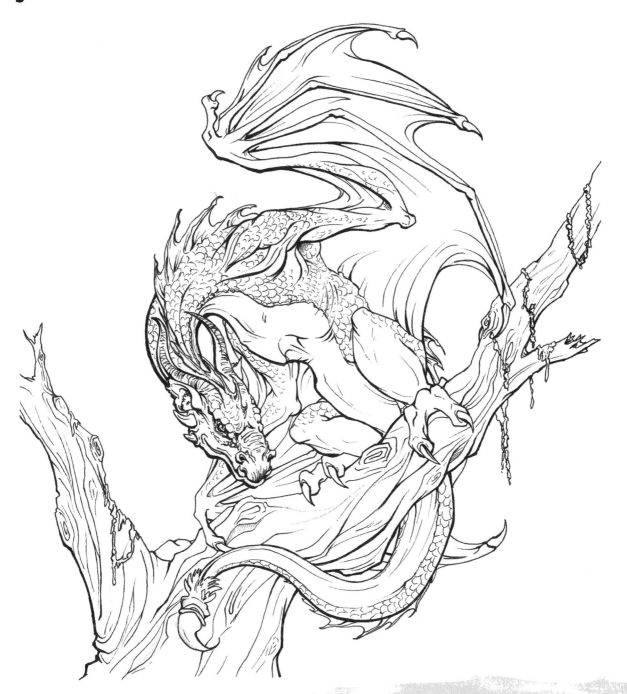

Not Quite a Dragon

A dragon is not a wyvern. The way to tell the difference is fairly simple: A wyvern has two legs and two wings, does not breathe flames and it usually has a barbed tail. All these conditions must be met in order to qualify the creature as wyvern-kind. If your "dragon" happens to have a couple of these traits, it's just a dragon variation and not a wyvern.

Basilisk

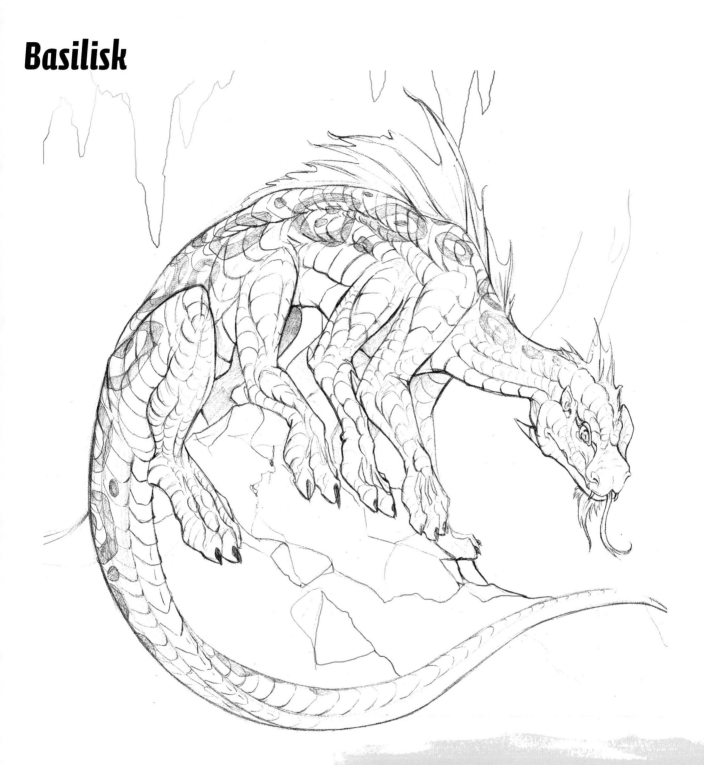

Stone Cold Stare

Basilisks are unusual creatures. Not only do they have very different forms, they also have two different abilities: lethal breath and lethal stare. Their breath will kill you and their gaze will turn you to stone.

Most basilisks are not brightly colored. Their stare is so lethal that most foes don't last long against them, so they don't need to show off their scariness.

Dragon Lich

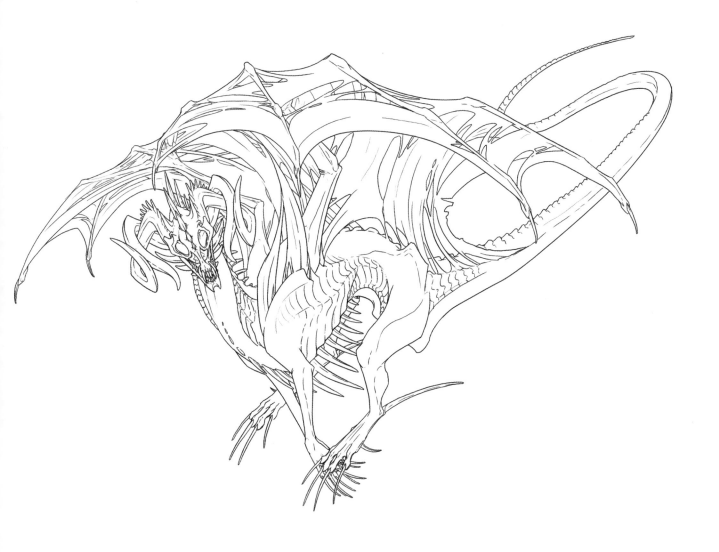

Zombie Dragon

All good things must come to an end...but evil things think that's rather dull, so they like to stick around long after their natural end has come and gone. Meet the dragon lich: He's big, he's bad, and he may or may not be falling apart.

About the Author

Jessica "NeonDragon" Peffer is an illustrator and author of IMPACT's *DragonArt™ How to Draw Fantastic Dragons and Fantasy Creatures*, *DragonArt™ Fantasy Characters* and *DragonArt™ Evolution*. Her site, **NeonDragonArt.com**, is a community where fans explore her art, comics, art tutorials, products featuring her art, message boards, links and other features. Her work has been licensed for T-shirts, posters, stickers and other items. She is a graduate of the Columbus College of Art and Design. She has also done character and logo commissions.

DragonArt™ Color Workbook. Copyright © 2012 by Jessica Peffer. Manufactured in China. All rights reserved. No part of this book may be reproduced in any form or by any electronic or mechanical means including information storage and retrieval systems without permission in writing from the publisher, except by a reviewer who may quote brief passages in a review. Published by IMPACT Books, an imprint of F+W Media, Inc., 10151 Carver Road, Suite 200, Blue Ash, OH 45242. (800) 289-0963. First Edition.

 Other fine IMPACT Books are available from your favorite bookstore, art supply store or online supplier. Visit our website at fwmedia.com.

16 15 5 4 3 2

DISTRIBUTED IN CANADA BY FRASER DIRECT
100 Armstrong Avenue
Georgetown, ON, Canada L7G 5S4
Tel: (905) 877-4411

DISTRIBUTED IN THE U.K. AND EUROPE
BY F&W MEDIA INTERNATIONAL, LTD
Brunel House, Forde Close, Newton Abbot, TQ12 4PU, UK
Tel: (+44) 1626 323200, Fax: (+44) 1626 323319
Email: enquiries@fwmedia.com

DISTRIBUTED IN AUSTRALIA BY CAPRICORN LINK
P.O. Box 704, S. Windsor NSW, 2756 Australia
Tel: (02) 4577-3555

Edited by Vanessa Wieland
Designed by Wendy Dunning
Production coordinated by Mark Griffin

Ideas. Instruction. Inspiration.

Check out these IMPACT titles at impact-books.com!

Download FREE pages at
impact-books.com/dragonart-workbook.

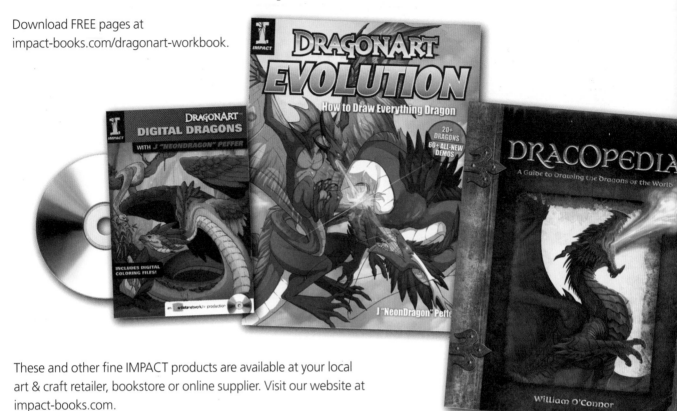

These and other fine IMPACT products are available at your local
art & craft retailer, bookstore or online supplier. Visit our website at
impact-books.com.

IMPACT-Books.com

- ▶ Connect with your favorite artists
- ▶ Get the latest in comic, fantasy and sci-fi art
 instruction, tips, techniques and information
- ▶ Be the first to get special deals on the products
 you need to improve your art

**Follow IMPACT for the latest news,
free wallpapers, free demos and
chances to win FREE BOOKS!**

Follow us!